HOW TO DRAW ANYTHING

Scriberia was founded in 2009, by Dan Porter and Chris Wilson. Sharing a belief in the power of pictures to make thinking, working and communicating easier for everyone, they set about building a business based on that principle.

Today, it underpins all the work the Scriberia team undertake in their London studio. Whether creating beautiful animations or illustrations, or helping a roomful of engineers explore and express their ideas in visual form, they maintain a steely focus on making pictures that achieve their purpose. 'Hard-working pictures', as Dan and Chris would say.

And, as you will soon find out, you don't have to have exceptional artistic talent to draw a great little hard-working picture, it takes confidence, clarity of thought, and a few surprisingly simple tricks.

www.scriberia.co.uk

Other titles in the series:

HOW TO
DRAW ANYTHING

SCRIBERIA

Quercus

First published in Great Britain in 2017 by

Quercus Editions Ltd
Carmelite House
50 Victoria Embankment
London EC4Y 0DZ

An Hachette UK company

A CIP catalogue record for this book is available from the British Library

ISBN 978 1 78648 539 7

Jacket design by Setanta, www.setanta.es
Jacket illustration by David de las Heras
Illustrations by Scriberia
Author photo © Maria Moore, www.mariamoore.co.uk

10 9 8 7 6 5 4 3

Text designed and typeset by CC Book Production

Printed and bound in Great Britain by Clays Ltd, Elcograf S.p.A.

CHAPTER I

Why Draw?

I think of myself as a visual person…but I really can't draw.

The first part of that statement is probably true; after all, something made you pick up this book. Many of us find pictures accessible and engaging, we interpret them instinctively and they're crucial to how we navigate the world around us. They can make us feel more connected to a subject, and help us to understand and remember it. A lot of people would say that they think visually too – that mental images form in their minds automatically when they're developing ideas.

But the second part of the statement definitely isn't true. You can draw – we promise. OK, you might never be a Michelangelo or

1

a Rembrandt. But if you want to use drawing to explain, to plan, to problem-solve, to tell stories or to make others think or laugh, then we're willing to bet that it's well within your capabilities. And the good news is, if you consider yourself to be a visual person, then the day on which you're drawing freely and confidently is much closer than you might think. The hard work's already being done in your head. Now, in order to get it down on paper, you just need to regain your confidence and focus, and get back into the habit of drawing.

But how can I regain my confidence – I've never been any good at drawing?

Are you sure about that? Let's take you back to your childhood. You're six years old and you're sitting at the kitchen table; Mum's making dinner and light is streaming through the window. You're drawing! Animals, spaceships, dinosaurs, family or a something concocted entirely from your imagination. Your pencil moves busily around the page, describing the thoughts in your head.

Back then, drawing came naturally to you. Not necessarily in the sense that you had a natural talent for it, but in the sense that you had an instinct for it. You didn't hesitate, you didn't overthink, you

didn't worry about being good enough – you just did it, enjoying the feeling of giving your ideas shape and colour on the page.

So, when did it all go wrong?

It was probably around the age of nine or ten. That's when your ability for self-appraisal developed, and, more than likely, it's

when your spontaneous approach to drawing started to tighten up. You noticed that there were rules to follow in order to make a drawing look 'correct', and discovered that applying those rules was tricky. At the same time, the ideas that flowed so easily from your young imagination were becoming more measured and rational. Hesitation and doubt

3

crept in and, suddenly, you weren't so sure what to draw, let alone how to draw it.

Looking across the classroom to that kid who was brilliant at drawing, and at all those lovely illustrated books around you might have left you feeling inadequate in comparison. You might have been told (or perhaps you concluded by yourself), that drawing wasn't your 'thing'. And pretty soon, your relationship with it was reaching the end of the line. It was time to focus on other skills. Without a backward glance you left drawing behind, before giving yourself the chance to discover what a fun – and fantastically useful – skill it is to keep up your sleeve.

But realising the things you're not good at is part of growing up, isn't it?

Hang on a minute. Nobody ever suggests we should give up writing if we're not showing early signs of literary greatness, do they? We all know it's possible to get your message across perfectly well in writing, without having a Booker or Pulitzer Prize on your mantelpiece. We do it every day – on our Facebook pages, in our emails, in birthday cards and so on. It may not be a work of genius, but it gets the job done – a thought has been launched into the world

in a form that others can understand. When we learn to write, we gain an important life skill – a practical means of communicating.

Drawing should be no different. It's also an incredibly practical way of turning what's inside your head into something more tangible and shareable. Yet we've lost sight of drawing as a functional means of expression and have become fixed on the idea that it's something very refined that requires a special talent. And if you don't have that talent, why fight it? Better to leave it to those that are good at it, right?

Wrong! Not every drawing needs to be framed and hung on a wall. Some drawings, including some truly world-changing drawings, just do enough to get the message across. They allow us to see what is meant and that's where they stop. And these powerful, wonderful, humble little drawings are well within your grasp.

Maybe, for some people, but you haven't seen my drawings – they really are terrible!

Of course they are! You wouldn't expect to smash an ace if you hadn't picked up a tennis racquet for twenty years, would you?

Drawing's no different. Whether you're an artist or not, drawing is something you have to work at. But, if you give it the time and attention it deserves, it's a skill that anyone can learn.

The Victorians proved it. Back then, if you were lucky enough to get a good education, drawing was central to it. Not because they were training future artists, but because they were training future doctors, nurses, scientists, engineers, builders, cartographers, carpenters, plumbers and gardeners. They understood the importance of being able to illustrate what you were thinking. They recognised the power of drawing to reveal, explain and clarify, where words alone fell short. Florence Nightingale's visualisations of mortality data in the Crimean War saved many lives. From the scruffy sketchbook pages of Alexander Graham Bell came the first telephone. Charles Darwin grabbed a scrap of paper and mapped out the tree of life.

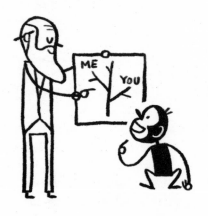

Were they all naturally talented artists? Unlikely. Did they outsource their drawings to someone more artistically gifted? Why bother? They'd all been taught to draw and picking up a pencil to visualise their thinking felt natural to them. They understood that a good drawing is not necessarily

a beautiful one, but one that does its job. Not a work of art, but art that works. As the Victorian artist, writer and social thinker, John Ruskin, wrote: 'Better the rudest work that tells a story or records a fact than the richest without meaning.'

But couldn't I just write it instead?

Drawing's not an alternative to writing, it's a complement to it. Of course, words can be incredibly versatile and effective, but there are times when they fail us, or at least, struggle to describe what a picture can do quite easily. The old saying 'a picture says a thousand words' is often true. A clear drawing can save you some serious linguistic mileage. Sometimes, even a complete non-drawer will know, instinctively, that it's better to draw something out than attempt to explain it verbally. When a set of directions gets complicated, who doesn't reach for pen and paper and scribble out a rough map?

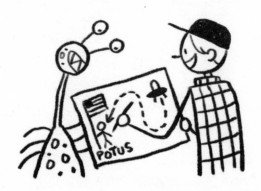

Pictures are particularly good at showing how one thing relates to another, whether that's physically, or conceptually. How confident would you be about getting the kitchen of your dreams if you'd only read a description of it before handing over your money?

Clearly, that would be far too risky, but a picture ensures everyone's expectations are aligned. Or imagine trying to explain verbally all the relationships that exist through five generations of your family. It would quickly get incredibly confusing, wouldn't it? But a family tree visualises all that complexity in a way that is simple, logical and unambiguous.

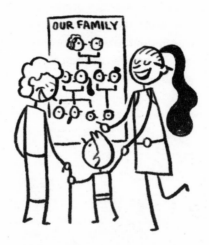

And those are just examples of the practical value of drawing. Pictures, done well, can also be more engaging and memorable than the written word; helping us grasp ideas more quickly and inspiring a greater emotional connection. In short, being able to write and draw makes you a more complete communicator. Surely, in the so-called 'age of communication', that's something worth striving for?

Well, yes – but I'm just worried my drawings might not communicate well, and if that's the case, what's the point of drawing at all?

This book tackles that concern head on. It focuses on the simple, achievable aim of creating drawings that communicate with clarity.

If people can see what you mean, if the picture is legible, then you have a powerful means of expression at your pencil tip.

Obviously, we're hoping you'll soon have the confidence to share your pictures with others. But even if you prefer to keep your sketchbook under wraps – for now at least – the very act of drawing can still be incredibly valuable on a personal level. We hear a lot about mindfulness these days, but there can be few activities as genuinely mindful as drawing. While the pace of life generally encourages us to make rapid assumptions, drawing forces us to be much more observant and focused. 'When you draw an object, the mind becomes deeply, intensely attentive,' says legendary graphic designer Milton

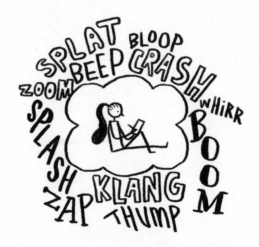

Glaser, 'and it's that act of attention that allows you to really grasp something, to become fully conscious of it.' To draw something is to understand it better. Like a cartographer mapping the coastline of a newly discovered land, you can use drawing as a personal voyage

of discovery. If in doubt, draw it out – and that goes for ideas, plans and processes, as well as things in the physical world.

Studies have shown that drawing, whether observational or conceptual, is a fantastic cerebral workout, sparking activity across many different areas of the brain simultaneously. Regardless of how good an artist you are, when you draw you're exercising and developing your visual processing powers, your fine motor skills, your spatial awareness and your ability to plan, reason and solve problems. It's also proven to aid the memory. Recent research suggests that when we draw, our brains call upon past experiences as part of the visualising process. It's thought that this cognitive act links the drawing and its content to our long-term memories. Ideas conveyed by text, on the other hand, enter the short-term memory and don't tend to hang around so long.

It's worth persisting with, even if you don't show your drawings to anyone else. The brain loves us to draw and rewards us just for having a go and sticking at it. As well as boosting the memory, drawing encourages ideas to flow more freely. 'When I try to imagine

a film, lots of new ideas occur simply by trying to draw it,' says director Terry Gilliam. And there may be a chemical reason for what Gilliam is describing.

Drawing encourages dopamine to be released in the brain, a natural chemical that both relaxes our creative inhibitions and makes us feel great about having new ideas. It's a virtuous circle: drawing leads to creativity, which leads to ideas, which in turn leads to more drawing. All it takes is a little push to get some momentum going and suddenly you're that six-year-old kid at the kitchen table again, uninhibited, having fun and never short of inspiration. And when drawing makes you feel good about yourself, you'll start feeling good about your drawing. Pretty soon, you'll be stopping people in the street to show them your sketchbook!

CHAPTER 2

Drawing the World around You

If we asked you to pick up a pencil and write out the alphabet, do you think you could manage it? Of course you could.

ABCDEFGHIJKLMN OPQRSTUVWXYZ

Now imagine that you could put a stick of dynamite under those letters and blow them to pieces. Once the dust had settled, you'd be left with a pile of bits; straight lines, curved lines, right angles and loops. And if you sat and played with those fragments for a few minutes you'd find that it was quite easy to combine them in new ways to create shapes, symbols and even simple pictures.

To save you getting your hands dirty, we've rummaged through the debris and pulled out some bits we think are particularly useful. Consider this your drawing alphabet. We're confident there's nothing that can't be drawn using this simple set of shapes:

∪ | ◁ ⊚ ⌓ □ ○
Ƽ · ∫ ▽ ⊱ ⅄

So, in knowing how to write, you can already make all the marks you'll ever need to be able to draw. The motor skills are no different. It's a bit like when the comedian Eric Morecambe told the conductor, André Previn, 'I'm playing all the right notes, but not necessarily in the right order.'

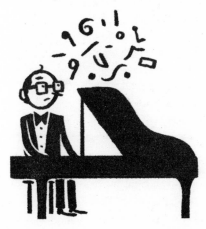

Obviously, getting the notes in the right order, or in our case, the marks in the right place, is the hard part. But, unlike tackling Greig's 'Piano Concerto', it doesn't take long to be drawing quite respectably once you've established the right mindset.

Because that's what it is — a mindset. Before the pencil touches the paper, drawing happens in your head. It requires you to see and think about the world around you in a different way. With practice, you'll develop a knack for extracting

the information you need to draw whatever it is you're looking at, spotting the distinctive shapes and lines that characterise it. The artist, Balthus, called this 'drawing with the eyes', and the better you are at the seeing and thinking parts of the process, the easier it is to pick up a pencil and draw.

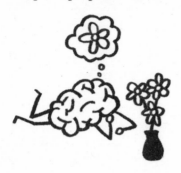

When drawing something real – a thing, a person or a place, for instance – it's important to remember that it's an act of interpretation. It's a collection of marks on a flat surface that represents a three-dimensional object in the real world. And like all interpretations, it's hugely subjective – there's no right or wrong way to translate what you see into marks on a page. It might be very detailed or it might be very minimal, it might strive for accuracy, or it might exaggerate wildly. It's up to the individual artist to decide what's important to them, which is why art is so endlessly varied and fascinating!

The same is true of drawing people. Find a photograph, then take a moment to consider how two different artists might approach drawing the same face. Below are two examples; one detailed, one much less so. Next to each drawing we've added the artist's 'mental list' of what they've deemed important to include. Both are

perfectly good representations of the subject, but the priorities of the two artists are very different. The first is quite minimal, giving just enough clues as to what the person looks like. The second includes a lot more detail – it has a much longer list of elements. The shadows and areas of highlighting give a sense of depth and solidity, the lines on the face add greater subtlety to the sitter's expression, and the variety of the marks help to make his beard and clothing more lifelike.

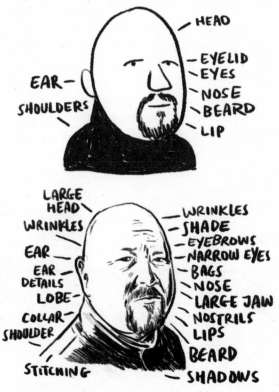

It aims to give a realistic impression of the person, and it's a nice drawing. But if you want to learn how to draw anything, this is the slow, scenic and probably rather painful route.

We haven't got time for all that! We want to get you drawing confidently as quickly as possible, so the other approach will be our guide. You won't be drawing like Ingres or Rubens any time soon (sorry about that), but don't start thinking you can relax, we've still got lots of work to do. Let's take our inspiration from another master of his art, the creator of Bugs Bunny and Daffy Duck, Chuck Jones: 'The whole essence of good drawing – and of good thinking, perhaps – is to work a subject down to the simplest form possible and still have it believable for what it is meant to be.'

16

That's our mission in a nutshell: to simplify. And it's harder than it sounds. We're going to limit ourselves to using the set of elements we identified as our drawing alphabet earlier on (see p. 13). You can stretch them, squash them, rotate them, bend them and slice them up, but they should be all the pieces you'll ever need! We're going to be thrifty with them too, using only what's absolutely necessary. It might seem counterintuitive to put constraints on our creativity, but, actually, it's very helpful. A set of rules gives you more control over what you're doing; a language in which to express yourself.

The Five Commandments

Before we go any further, you must promise to do the following:

1. *Save your money*
Tempting as it may be, don't head to an art shop and spend lots of money on sketchbooks full of gorgeous, creamy, heavyweight paper – not yet, anyway. Use the most inexpensive stuff you can lay your hands on, free if possible: waste paper, bog-standard notebooks, cheap- as-chips kids' drawing pads, Post-its, old envelopes even. That way you can relax without the worry of 'spoiling' your lovely new stuff. You'll draw with greater freedom and, as a result, you'll develop faster.

2. *Concentrate!*
It's easy to look at professional artists and illustrators and assume that drawing is an unforced, off-the-cuff sort of activity for those

lucky enough to possess the skills. It's not. Years of work have gone into making it look easy, and every drawing presents a challenge, however experienced you are. As a beginner, the biggest favour you can do yourself is to allocate to drawing the headspace it deserves. Focus! The brain finds it particularly hard to talk and draw at the same time, so – and we mean this in the nicest possible way – shut up and concentrate!

3. *Embrace your imperfections*

We often hear people say things like, 'I couldn't draw a straight line to save my life!', as if drawing a straight line should be the easiest thing in the world. Well, no one can draw a straight line – not freehand at least – so don't worry about it. When you haven't developed a confident sense of your own approach yet, it's easy to be self-critical. But, just like your handwriting, the quirks and wobbles in your drawing are – within reason – what make it unique. Picasso apparently said, 'Style is the difference between a circle and the way you draw it.' People want to see the human behind the drawing.

4. *Work like an Egyptian*

We take it for granted today, but giving the illusion of perspective in a picture has only been around for a few hundred years. It's often seen as the 'proper' way to draw things, but bear in mind that it's a trick, just a clever way of giving the impression

of three-dimensionality. It's also quite a complicated thing to pull off successfully. But a picture doesn't have to pretend to be something it's not. And perspective is, almost always, an unnecessary complication. So, make life easier for yourself, focus on drawing clearly rather than realistically, and keep it two-dimensional – in other words, flat.

5. *Commit to that mark*

For people who don't draw often, there's a temptation to sketch with a fuzzy, feathery line. The pencil creeps across the page haltingly, apologetically, afraid to commit fully to making its mark. Hope as you will that this looks charmingly sketchy, it's sketchy in the other sense unfortunately – vague and slightly feeble.

If you don't believe in your drawing, no one else will. So, before you put pencil to page, figure out where you want that line, then go for it, in one confident stroke. You might not get it spot on every time, but your work will always be clearer, bolder and far more convincing as a result.

Time to Shape Up

OK, so let's start by practicing 'drawing with the eyes'; looking at things and breaking them down into a set of simple elements. We're naturally quite good at reading the shape of objects around us. Our brains are hard-wired to look for edges – it stops us bumping into things! We need to make the most of that ability now. Here are a few examples of drawings with simple shapes to get you started...

Now try a few yourself, using photos or objects you see around you for reference. How would you break them down into a set of simple shapes? Practise looking without drawing at first, then have a go at getting a few down on paper, using your drawing alphabet. Can you push yourself to draw twenty things, as simply as possible? But make sure you provide just enough detail for someone else to recognise them.

It's a bit like playing with Lego. Your drawing alphabet presents you with a finite set of options, a set of building blocks, but once you accept that's the way things look in the world you're creating, it's actually a very liberating and flexible way to draw.

Drawing is Decision-making

So, everything is awesome, as our Lego friends would say. Or is it? Were you good at deciding what to draw and what not to? Did you find it hard to let things go? Or were you too brutal, ending up with something minimal and meaningless?

It's all about finding that balance between detail and absence of it. It's having the confidence to decide what to include and more importantly, what NOT to. When you're making good decisions about what to leave out, your audience will fill the gaps without even thinking about it. When that happens, you've engaged them. You've invited them into the picture and asked them to be a more than a passive observer. People like that – and it makes a lasting impression.

Developing your instinct for finding that sweet spot isn't going to come overnight, though. It takes lots of practice to get to know yourself as an artist. Don't be daunted by that, enjoy it. It's pointless striving for perfection, that way madness lies, but you will get better, much better, if you continue to doodle, experiment and have fun with the process. Your sketchbook should not be a shrine to excellence but a safe space in which your journey as an artist can happily, peacefully and playfully meander onwards and upwards. Before you know it, you'll be drawing with genuine confidence.

Choose one of these objects in the list below and really get to know it. Look at it from different angles – top down, face on, side on – and, referring to the drawing alphabet, work out which simple shapes you need to combine in order to draw it. Push yourself to draw it over and over again.

- a teapot
- a shoe
- an aeroplane
- a pineapple
- a grand piano

If you can't find the real thing to work from, you can always find visual references in books, magazines or on the internet. Use

realistic images, though – photos or accurate drawings – so that you're forced to make your own decisions about which details are important. Look at how we've taken this detailed picture of a pig and used the shapes of our drawing alphabet to create simplified versions of it from a few different viewpoints. Remember, it's much easier to avoid tricky angles and keep things flat.

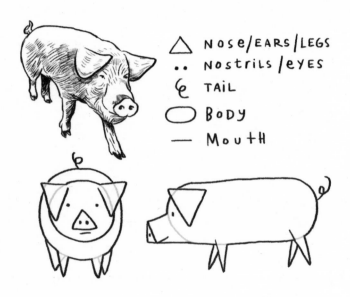

Spicing Things Up

What those drawings look like will vary from person to person. There are as many ways to draw a pig as there are ways to make spaghetti Bolognese. Everyone has their own version. And, just as in cooking, we make our list of 'ingredients', and, quite instinctively,

give some of them a little more oomph than others – which ones is a matter of personal taste. The more you heighten certain features, and lessen others, the more expressive your drawings become. You may find yourself entering the realm of cartooning here, but if your aim is clear and impactful visual communication, this is no bad place to be.

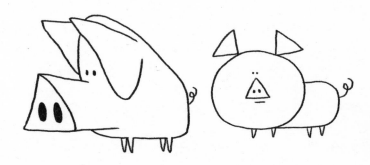

Let's experiment with that now. Working through the following list, identify six features that you feel are key to the appearance of that item. Then combine them to make a picture, but try exaggerating a couple of those features. Don't just draw each one once – play, test and iterate. Aim to fill a page with different versions of the same subject.

- a double decker bus
- a chicken
- a castle
- a witch
- a wedding cake

Stand Aside, Stickman. Introducing…Brickman

Whatever it is that we want to draw, people are likely to be at the heart of it. Non-drawers often say they can't draw anything more than a stickman, but, actually, our simple visual vocabulary gives us plenty of better options. The problem with the stickman is that he just can't act. If Keanu Reeves was the lead in every film you ever saw, it's fair to say you'd lose interest in movies pretty fast. Instead, in drawings, as in movies, we need a cast of characters who can express themselves naturally. And this little guy is a great first step. Meet Stickman's less uptight, more expressive cousin opposite: Brickman.

The differences aren't huge, but they're significant:

1) By replacing the stick-thin body with a more substantial brick shape, he's suddenly got more presence. He's a confident little chap, who justifies his presence wherever you put him.

2) The brick-shaped body also forces the arms and legs into a much more natural position. Now he's got shoulders and hips, he looks and acts more like a proper human being.

3) Don't worry about joints too much. Walt Disney pioneered these 'rubber hose' arms and legs because elbows and knees are awkward to draw and animate. If you just want to give an impression of an action or gesture, these bendy limbs are the way to go…it also means Brickman is great at yoga. Anatomical accuracy is an unnecessary challenge, so don't even go there.

4) Moving the head away from the body a little loosens things up

nicely, allowing you to vary its position. Draw a neck in the gap or just leave the head floating.

5) The nose has an important job. It acts like a weathervane, giving a clear indication of the direction a person is looking in.

6) A dot for an eye humanises your character.

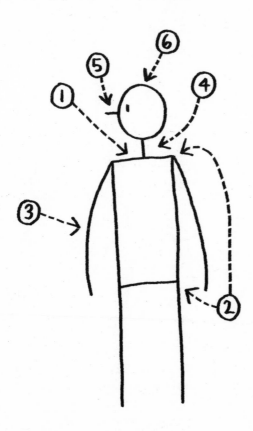

Let's have a look at some other body positions now...

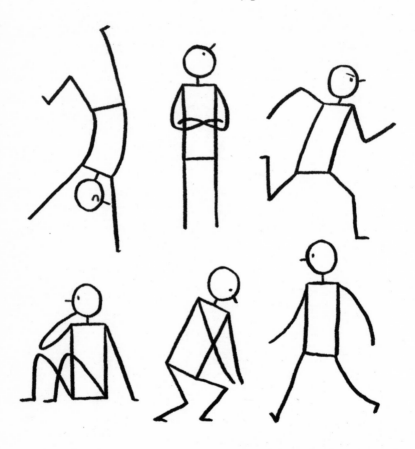

Spend an hour or two getting to know this guy and he'll be a faithful friend for life! There's almost no scenario he can't help you describe. Once you're confident, you can start adding a few additional details for greater variety and diversity:

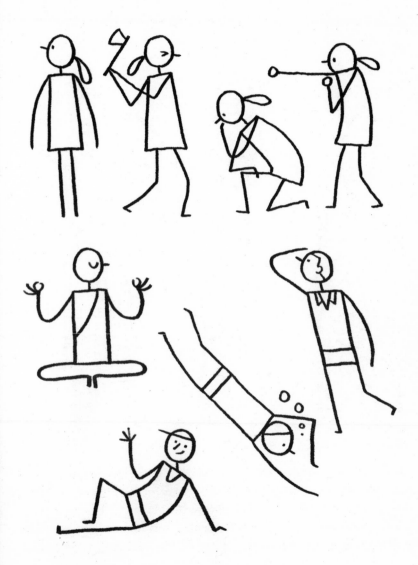

It's not the only way to draw people though – here are some other ideas based on our simple alphabet of shape combinations...

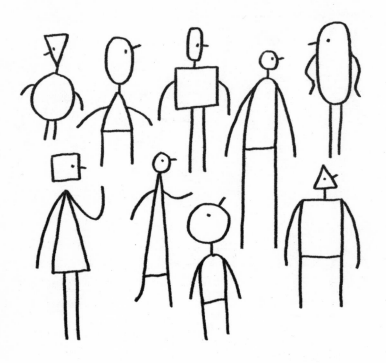

It's Your Party

Our final tip, when drawing people of any shape or size, is to imagine them all as guests at your party. A good host doesn't want any guest to look or feel awkward, do they? They'd never let anyone stand around looking lonely, lost and aimless. So, try to find a way to make the people you draw look comfortable – put

their hands on their hips, find them a friend, get them a drink, for goodness' sake! Anything to breathe a bit of life into them. Suddenly you'll find them transformed into characters that people can empathise with.

So, how about using Brickman, or one of his pals, to describe some actions and scenarios? Remember, the objects he's interacting with should also be drawn as simply as possible. And don't you dare bring Stickman back!

- Flipping a pancake
- Digging a hole
- Playing the piano
- Skipping with a rope
- Diving into a pool
- Chopping wood
- Watering a plant
- Playing tennis

Character Building

We're all familiar with emoticons these days, so we know that very simple marks can convey a huge range of moods and feelings. The ability to show human emotions visually makes a picture instantly more engaging and allows it to tell a deeper story. And, with just a few strokes of the pencil, there are other ways of investing the people you draw with more character and variety. There's no need to break out of our drawing alphabet. Experiment with hairstyles, glasses, accessories, beards, moustaches and facial features. But remember, keep it simple or your characters will start to draw too much attention to themselves. And, as every experienced party host knows, that rarely ends well.

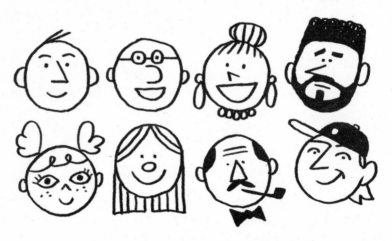

If you want to draw someone in particular, follow the process we went through earlier when adding some exaggeration to your drawing (see p. 15). Identify a few details that make that person

unique – the first four or five things that come into your head are usually the best – and amplify them a little, adapting your standard character accordingly. Here are a couple of examples:

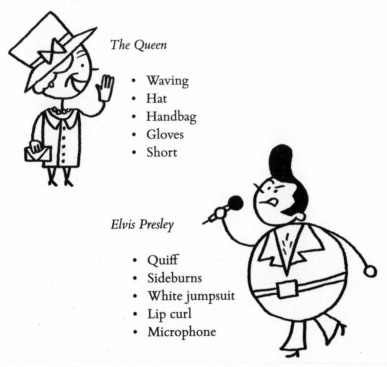

The Queen

- Waving
- Hat
- Handbag
- Gloves
- Short

Elvis Presley

- Quiff
- Sideburns
- White jumpsuit
- Lip curl
- Microphone

Now you try a few: famous people, family members, work colleagues, that guy opposite you on the train…whoever you want. We're not going for a caricature exactly: we just want to give enough clues to make them clearly identifiable. And as always, don't settle for the first one you do, keep experimenting.

Feeling Confident?

We can draw things, and now we can draw people. How about we celebrate our newfound versatility by combining the two? Just think, now you can draw a baby hailing a taxi, Spiderman riding a goat, a fat policeman on a skateboard, a boxer wearing a bucket on his head, two old ladies in a canoe and ever so many other useful things, just by bringing together some simple shapes and lines. The ability to adapt what you know to new and unexpected challenges defines your usefulness as an artist. So let's test those improvisational skills now with some random combinations. Draw something from List A interacting in some way with something from List B below to form one coherent picture. Try out as many combinations as you can.

List A	List B
Supermarket trolley	Dinosaur
Christmas tree	Garden gnome
Watering can	Teddy bear
Helicopter	Marilyn Monroe
Trumpet	Statue of Liberty

Making a Scene

Now we're bringing things together, our pictures are getting more sophisticated. You can draw a woman, you can draw a cup of tea, and so you can draw a woman holding a cup of tea. The combination hints at a story, a glimpse of life being lived, but without further clues the interest ends there. Up to this point, our objects and characters haven't inhabited a world of any sort – they've just been floating in the empty nothingness of the paper they're drawn on. But even if we're being miserly with detail, a little more context is perfectly justifiable if it aids or deepens our understanding of the picture.

So let's add a bit more context around our tea-drinking friend. She's sitting in an armchair, she lives in New York, it's winter and she has a cat. That's quite a lot of additional information, so how shall

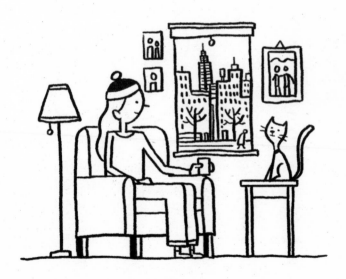

we deal with it? Well, we could just draw it all out. The armchair's easy, we'll just draw that under her body, and adjust the limbs so she looks comfortable, cup of tea in hand. The cat could be near the chair. The location and the season are trickier, but since we're talking about the world outside her apartment maybe we can show them through the window – a recognisable skyline? People walking past in winter coats? Or how about trees without leaves? Yes, let's go with that.

Even now, as our picture starts to get more sophisticated, our drawing alphabet stands us in good stead. The furniture is made up of rectangles and some elongated 'U' shapes, the buildings outside are simple boxy shapes decorated with dots and lines, and even the cat is just a combination of triangles and curves, with some simple features added for the face, as we can see below:

So what do we think of our New York scene above? Well, it's OK, but it's hard to know where you're supposed to be looking, isn't it? Everything in the picture seems to be of similar significance. What this drawing needs is clarity of purpose. If we can establish what we most want the viewer to notice, we can create different levels of emphasis within the picture. It's like being a film director choosing

what to focus the camera on and how to frame the shot. The eye is led to the part of the image where the detail is richest. The rest of the image is less precise, but serves to create a sense of depth and context. Look at how the framing and focus can shift according to what is deemed the central idea:

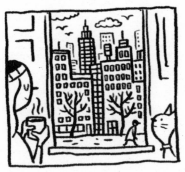

The focus is on the world outside the window

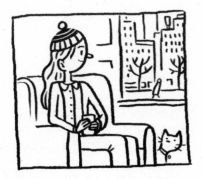

The focus is on the woman

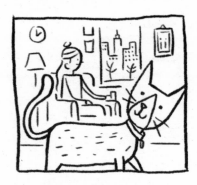

The focus is on the cat

Once you've identified what you want your viewer's key take-away to be, you make that point of focus 'King' within your picture. All other detail must support it, rather than compete with it. Working from observation, draw a few scenes and choose a definite area of emphasis in each. It might help to draw a frame first, so you have a clear sense of where the boundaries of your image are.

Less is More

We've taken you on a whistle-stop tour of the basics of clear, simple, drawing. Hopefully, you're feeling confident and reassured that as a bright and resourceful person you're in possession of everything you need to make drawing a skill for life. While some styles of drawing demand patience, discipline and years of study, drawing in the way we've described demands nothing more than a sharp and lively mind that can cut to the heart of the matter. It's all about having a confident sense of what you want to communicate, what's important to you, and then stripping away everything that isn't.

Strange as it sounds, you should be trying *not* to draw. Your brain should be working overtime to simplify the message and make your hand's work easier. And when your pencil does hit the paper, you have to make every mark count. The wartime graphic designer Abram Games had a mantra that serves us well in this endeavour: 'Maximum meaning, minimum means'. It may take a few attempts to get there but, ultimately, nothing should be on the page that doesn't serve the concept you want to convey.

CHAPTER 3

Making the Invisible Visible

Since the dawn of the internet, we've evolved. We're more visually literate than ever; we now navigate the world, online and off, via pictures – hundreds, possibly thousands of times a day. And with our smartphone cameras ever ready, many of us have become skilled in using photos to express ourselves and document the visible world around us – where we are, what we're doing, who we're with and so on. Now, of course, you can draw the world around you, too. Great! But how do we picture what can't be seen? How do we show the impossible, the imaginary, the conceptual and the futuristic? How do we reveal sounds, smells and hidden feelings? You can't use your camera, that's for sure.

So far, we've concentrated on drawing what is visible, translating everyday objects, people and scenarios into simple pictures – mere mortal drawing, you might say. But drawing isn't bound by the laws of everyday life. Henri Matisse called drawing 'putting a line around an idea'. In other words, it's a way of showing people what they otherwise wouldn't have seen; of making the intangible tangible. As such, it can be infinitely more powerful and more charged with possibility than any photograph. And the good news is, you're now ready to unlock these superpowers and harness the full potential of drawing.

X-ray vision

If we told you to draw your house, it might look a bit like this:

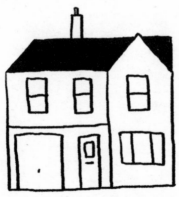

But is that really your house? Didn't you say you had a back garden? What about your nice kitchen – where's that in the drawing? And isn't a home really about the people that live there? Where are they and what do they typically get up to?

This simple picture of a house is like the flat-painted set in a western. It serves to satisfy a cursory glance – 'Oh right, that's the saloon over there' – but it's not capable of hosting any action or telling any stories. It doesn't give you a sense of what's within or behind. It's literally a façade – not a lie exactly, but certainly economical with the truth. If it's there just to add some context, some background detail, then that's fine. You wouldn't want it competing with the true focus of your image. But if your objective is to give your viewer a nuanced understanding of where you live, you'll probably want to provide them with some more information.

We have a challenge, though. If we're sticking to the principles we outlined earlier – keeping our picture simple, and not attempting to draw three-dimensional perspective – how do we show the rooms that lie behind the front wall, and how do we show the rooms behind those rooms?!

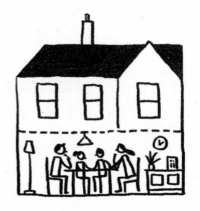

That's where our X-ray vision comes in. A drawing doesn't have to be made up of one scene, it can be composed of several. And as long as the drawing is clear and well organised, this will enable the viewer to peer through the outer surface to see the hidden truths within.

By tagging smaller pictures off the main image, you can reveal what's going on in several places at once. And this method isn't limited to showing what's hidden behind closed doors either. You can also use it to home in on things that are simply too small to be included in the bigger picture. In the image below,

observe how the tiny scene in the bird's nest can be drawn to the right scale to be easily understood, both independently and also within the overall context of the whole picture of the house.

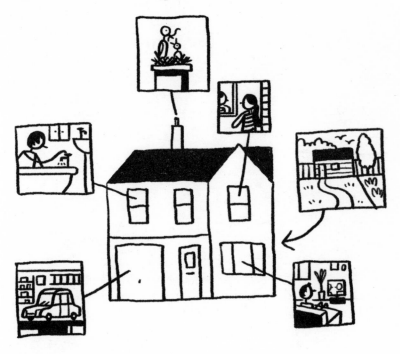

Extra-sensory Perception

Life provides us with a multi-sensory, ever-shifting experience. Pictures do not. So in order to draw non-visual phenomena, or to bring a sense of movement to a static image, we need to find pictorial equivalents. Fortunately for us, this is a problem that artists have been tackling ever since they were painting on cave walls. Over the years,

simple graphic devices have evolved that are widely understood around the world. Even if you're not an avid reader of comic strips, you should be able to work out what's going on in these pictures...

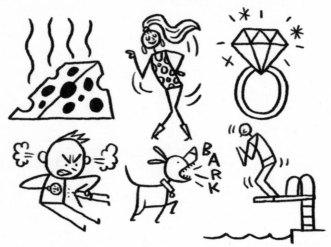

Though these marks are signs we can all understand, it's fun and often very effective to adapt them to make an even more expressive image. Look at how we're able to alter the message we're receiving from the first figure to the second in this picture simply by changing the type of marks we're using to describe what we're hearing:

Drawing also allows us to read minds, to reveal the ideas and emotions people often keep hidden from view. Bringing together, in one picture, the outer world of appearances, and the inner world of thoughts and feelings is a simple but powerful way to show real human complexity. It's a more complete view of a person, inside and out, and, as such, it feels much closer to the truth. Whether it *is* the truth or just a mischievous concoction is up to you – that's the power you wield when you pick up that pencil!

Thought bubbles traditionally document what's going on inside someone's head, of course – and you can always try pictorial ones now you have the skills. But there are also more creative ways of revealing these secrets.

One great way of showing those inner thoughts and feelings is to adapt something that we'd ordinarily expect to show a straight, impartial reflection of reality – a shadow or a mirror image for example – and tweak it to create a powerful contradiction.

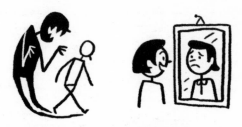

Time travel

When photography was invented, people were astounded by the concept of capturing a moment for ever. But, as fascinating as photographs can be as artefacts of our pasts, they can only contain

what was visible in that given moment. Whatever happened before or after the click of the shutter is lost.

As the artist, David Hockney, said in a recent interview: 'Drawing takes time. A line has time in it.' A drawing can never be a snapshot, even if you intend it to be. But – turning this to our advantage – through drawing, we can show the passage of time, and invite our audience to witness it. We can capture not just a moment, but a development, a change or an evolution.

Comic strips literally bring together separate timeframes to tell a story. The way that time is meted out is entirely within the artist's control, an incredible power that many of us might wish for in everyday life. They can slow down a moment, so that every fraction of a second can be taken in, just as they can accelerate through years, centuries or millennia so that these can be viewed in an instant. Time is at your command – with a pencil in one hand and a magic remote control in the other!

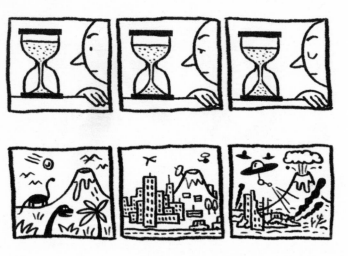

Drawing enables us to picture the future too, and if you can picture it, then you've got a much better chance of making it into a reality. If we can't make them tangible, future events remain a figment of the imagination – elusive, unreliable, hazy and impossible to share with any confidence. We can't photograph what's in our heads, so drawing provides the perfect way to give shape and substance to what we hope is yet to come. At Scriberia, we often work with company bosses who have a clear sense of how they want their business to progress, but are having real trouble sharing that goal with the team that will enable them to get there. A picture is often the answer. And it's not just in business that a drawing can help us communicate the futures we aspire to. We talk about having a vision in many areas of our lives – for our house, our career, our wedding and so on. And if other people can see it too, they can help us to get there.

Levitation

From business leaders to busy parents, we all have a tendency to focus on the here and now, and can easily lose sight of the bigger picture – if indeed we were ever aware of it at all. It's a struggle to

see the lie of the land when you're busy staying focused on hacking through the undergrowth. But there's nothing as valuable as an overview for refreshing your sense of proportion, purpose and direction. The bird's-eye view frees us from the distortions of a personal perspective:

Like a plain-speaking friend looking at a complex situation in our lives, it helps us comprehend the possibilities and the pitfalls inherent in it. From the tourist consulting the London Tube map to a writer working out the plot of a novel, it's the only way to truly understand how things connect or relate to one another. Challenging ourselves to draw from this elevated position can lead to profound insight and clarity. So, pencil in hand, now rise up and survey the scene.

Using maps to find our way comes naturally to us, whether they're on a smartphone, in an atlas or hastily scribbled on the back of an envelope. But maps are just as effective when charting more conceptual waters, though here they're often described as diagrams.

We find that clients often have their most productive conversations when they're working with us to create a diagram. Suddenly, they're forced to explain things simply and clearly to complete outsiders who are really only interested in what deserves prominence and how it all fits together. We said earlier in this book that drawing

is decision-making. Apply drawing to business, or indeed to any kind of project, and it's amazing how effectively it can help people to rationalise their activities and focus their energies. We often see processes streamlined, gaps spotted, opportunities highlighted and resources combined as a direct result of drawing things out in diagram form.

Diagrams can give abstract concepts form, a place to belong and a landscape to be part of. Expressed visually, and organised spatially, ideas can be seen in relation to each other, so that we get a better sense of their significance in the greater scheme of things. Where words can convolute and cloud our understanding, a diagram can explain a problem, a process or a set of relationships in seconds, providing a single, trustworthy perspective. In our studio, we've drawn diagrams to explain anything from the impact of Brexit on UK exports to

the snacking habits of Nigerian taxi drivers.

Maps and diagrams are often made up of abstract symbols – sometimes it's enough to just to give a concept a shape, any shape, to enable it to be seen and placed in context. But simple pictures like the ones we've been practising creating can help bring a diagram to life, making it more engaging and specific. It's not about drawing a scene, though, this is about mapping the relationships that make up the bigger picture. Linking your drawings with lines and arrows will make those connections clearer.

Data Alchemy

As ubiquitous as oxygen, data is everywhere in the digital age. Almost every action we take – from the things we buy, to the links we click on, to the calls we make and the buses we catch – adds to an ever-growing data pile.

But what use is data, without someone to shine a light on the stories within it? Someone who can transform it from a string of digits into something clear, concise and meaningful? Turn something cold and clinical into something human and relateable? Or make the invisible, visible?

When it comes to making data mean something, visualisation is the key. Hans Rosling, a doctor, statistician and a 'Jedi master' of data visualisation said: 'Having the data is not enough. I have to show it in ways that people both enjoy and understand.' And

while he employed an array of unconventional props, like building blocks and teacups, to achieve this, drawing is also a proven means to revealing the bigger picture.

Though data visualisation is not a new thing, it's fair to say it has never been a more useful superpower to possess.

And while pie charts and bar graphs are tried and tested visual aids, our newly acquired drawing techniques allow us to add an additional layer of creativity and interpretation. With data visualisations now appearing everywhere, from corporate reports to social media posts, the more memorable and engaging you can make yours, the better.

Fortunately, the way we've been learning to draw makes this incredibly easy. The simple shapes that have helped us build pictures of anything, from shopping trolleys to Elvis, now take on a dual role as information-carriers. Think about the pictures that are relevant to the subject of your chart or graph, and spot the shapes to use which can double up as containers of data. Here are a couple of examples:

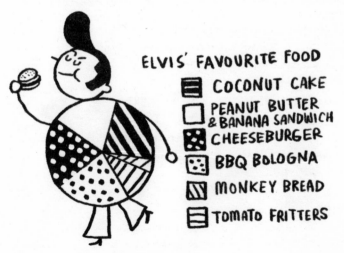

ELVIS' FAVOURITE FOOD
- COCONUT CAKE
- PEANUT BUTTER & BANANA SANDWICH
- CHEESEBURGER
- BBQ BOLOGNA
- MONKEY BREAD
- TOMATO FRITTERS

Graphs are usually rather abstract things, so making them more illustrative is a good way of creating a more tangible link between the data itself and the subject matter.

Shapeshifting

Once you wrap your head, and your pencil, around the idea of using visible things, like cups and blocks, to represent hard-to-visualise things, like digits and data, you're ready to road-test your next superpower: the power of shapeshifting metaphor.

If you pay attention, you'll notice metaphors cropping up in conversation almost constantly. We might talk of bottled-up anger, sunny characters, switching horses mid-stream, rainy-day funds and so on. Instinctively, we know that some things are easier to explain if we equate them to something else. And our reliance on metaphor proves that they are so much more than a creative indulgence; they're key to how we perceive and process the world around us.

Not all ideas are beautiful on the outside, or lend themselves to picture form. But if you can find the perfect metaphor, an idea can borrow its looks from something more visually stimulating to get the attention it deserves.

Further Superpowers

And if you can master these techniques, you'll be rewarded with a couple of additional superpowers to boot. The first is super-memory: an uncannily improved ability to remember whatever information you packed into your picture.

As we mentioned earlier, neuroscientists have discovered that

the act of drawing opens our long-term memory bank, where we then stash away the new information that we've just drawn. Mind-mapping has long been a favourite revision method for many a student cramming information into their brains before an exam. The process itself helps to cement those elusive facts in the mind and the resulting drawing acts as a permanent aide-mémoire.

The second bonus superpower is even more impressive. It's the power to communicate information and ideas across any language barrier. You may have failed every French exam you ever took, but if you can draw well you can express yourself with clarity and precision, wherever you are in the world.

CHAPTER 4

So, What's Next?

There's no way around it: getting good at anything takes practice. But knowing what and how to practise in order to get better, is the first crucial step. And it's one, we hope, with this book under your arm, you can now confidently take.

A drawing lives and dies by the thinking that lies behind it. Or, as the cartoon editor of the *New Yorker*, Bob Mankoff says: 'It's not the ink, it's the think.' And while that certainly turns up the heat on your thinking abilities, it should be a pretty reassuring approach for anyone still finding their feet with drawing.

From here on, you should imagine yourself as an apprentice. You've got the tools, you've learned the theory, now it's just a question of experience. You need to throw yourself at as many new challenges as possible, until you're thinking and working like the consummate pro.

It's a process that can't be rushed, but your progress will be satisfyingly steady. With the right approach, every drawing – in fact, every mark you make – whether you're satisfied with the end result or not, takes you another step closer to being able to draw absolutely anything.

CHAPTER 5

On Your Marks, Get Set, Draw!

The first step is the hardest. There's nothing worse than staring at a blank sheet of paper not knowing what to draw. The first time Chris (who would become one of the co-founders of Scriberia) had to draw live in front of an audience he asked Dan (who would become the other co-founder) what he should do if he froze and couldn't think

of anything to draw. 'Just get something up there,' said Dan, 'anything – a giraffe saying "Hello" if you like – just make a start and it'll start to flow, I promise.' Half an hour later, when Dan checked in on Chris's progress, the first thing he saw was a lovely picture of a giraffe saying 'Hello'. Chris had grabbed Dan's random example in desperation, but from that point on, his confidence had grown and he'd started to fill the wall with incredible drawings – some were even relevant to the meeting he was there to illustrate!

You just need to make a start. So, in the spirit of that moment, we've prepared a really rather random set of drawings for you to try before you go it alone. We did promise you'd be able to draw *anything*, and the next few pages prove there's really no challenge you can't tackle when you use your eyes, your brain, and your trusty drawing alphabet. We've even included a giraffe.

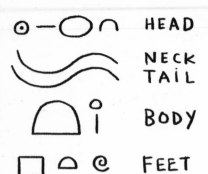

HEAD

NECK TAIL

BODY

FEET

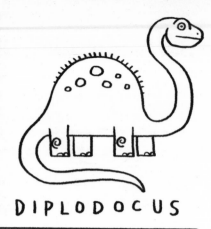

DIPLODOCUS

LIGHTHOUSE

LENS/DOME

TOWER

HOUSE

ISLAND

CLOUD

LADDERS

CAB

WHEELS

BACK

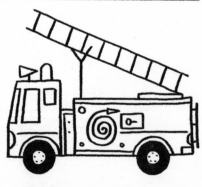

FIRE ENGINE

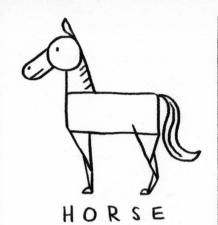

HORSE

	HEAD
☐	BODY
◠ ▷	LEGS
◡ ～	TAIL

	WINDOWS
I ⊂ ⊃	LIFERAFT
～	STEAM
⌣ ⌢	WAVES
I ☐ ○	DECKS
	HULL

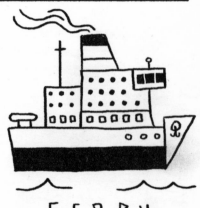

FERRY

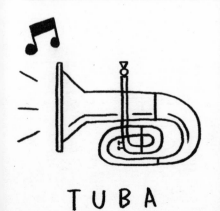

TUBA

○ I ☐	MUSIC
▽ ○ ▭	MOUTHPIECE
I ▷	BELL
⊂ I	BODY
I —	VALVE

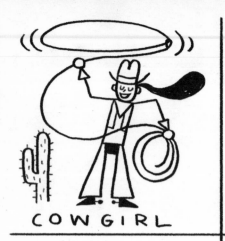

COWGIRL

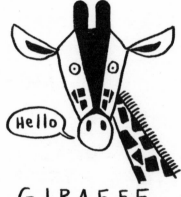

O -) S ſ u Δ HEAD

□ Δ — o BODY

— Δ □ o LEGS

ı ∿ O ◎ LASSO

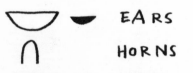
EARS

HORNS

HEAD

EYES

NOSE

MARKINGS

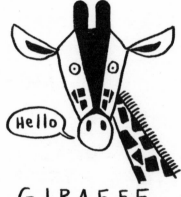
GIRAFFE

Hello

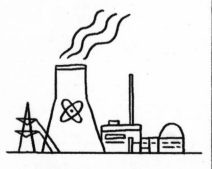
POWER STATION

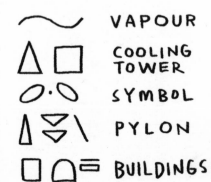

∿ VAPOUR

Δ □ COOLING TOWER

○ ·○ SYMBOL

Λ ▽ \ PYLON

□ ⌐ = BUILDINGS

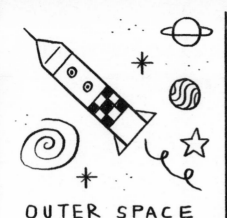

OUTER SPACE

人 1 0 · □ ROCKET
△ ℓ ℓ

○ ∼ 0 PLANETS

⑥ GALAXY

△ · 1 STARS

Y 1 ℓ TREE
ℓ ! △ ▫ TWISTER
○ □ 1 TRACTOR
△ □ · ▱ BARN
○ 1 ∠ U COW
□ ○ — ◿ TRUCK

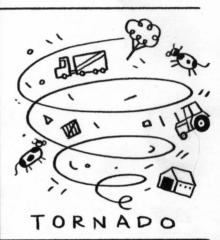

TORNADO

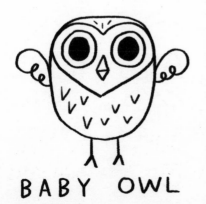

BABY OWL

○ ● EYES
△ ▽ BEAK
() FACE
v — FEATHERS
ℓ WINGS
Y FEET

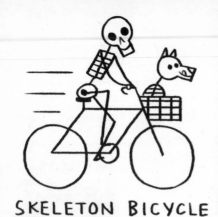

SKELETON BICYCLE

 SKULLS

 BONES

BIKE BITS

HAND

BOTTLE

GLASS

EMERGENCY

SHRIMP

VARIOUS SHRIMP BITS AND PIECES

CASTLE

∩ SS HILL

ຕ Y TREE

□ I △ ▷ TURRETS

∩ I □ WALLS
⊓ — & GATE

⌒⌒ △○= BIRD

△▽ ∪'-◦ WOMAN
□ ∪ ∟I

⌒ ⌒ ∩∩∩ CHUTE
⁄I) ⟍I⁄

PARACHUTIST

PARIS

人 ∩ I □ EIFFEL
TOWER

∩ I □ ARC DE
⊓⊓ TRIOMPHE

□ ◦∩ SACRÉ
COEUR

I ∧ = ¦¦

ω FRENCH
CLOUD

IDLENESS

ꓘ| ● (ᗯ∩ TREE

⊂ꓶ ℛ₁O·º SQUIRREL

∧ᅲ ☐|\ ROOF

O∪ ‒ ꗋ∧ IDLER

‒ º₀º GRASS
TO CHEW

○ NUCLEUS

○ PROTON

● NEUTRON

○ ELECTRON

ATOM

KONG

⌐||∪·
ᗰ·△ APE FACE
△□‿

o ═ ⌐ ∐ CURTAIN

∏:::: NEW YORK

SUBTERRANEAN BORING MACHINE

DRILL

CAB

TRACKS

ROCKS & BONE

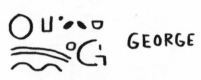

GEORGE

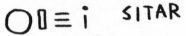

SITAR

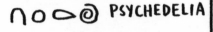

PSYCHEDELIA

MUSIC

GEORGE HARRISON

CUPCAKE

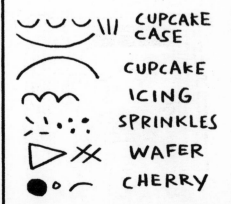

CUPCAKE CASE

CUPCAKE

ICING

SPRINKLES

WAFER

CHERRY

HOPE

 CASTAWAY

 PALM

 SUN

ISLAND

SHIP

 URN SHAPE

PATTERNS

 BULL

GRECIAN URN

LEVIATHANS

 GIANT SQUID

VS

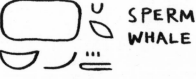 SPERM WHALE